Why We Travel

Travel Quotes Picture Book
Countries of the World Pictorial Coffee Table Book

ADA LUCAS

Copyright © 2013 by Ada Lucas

All rights reserved. This Travel or any portion thereof may not be reproduced or used in any manner whatsoever without the express written permission of the author except for the use of brief quotations in a Travel review.

Table of Contents

Introduction

Perhaps We Travel...

For Travel's Sake

To Find Ourselves

Because it Opens our Hearts and Minds

For The Sense of Wonder

For Fulfillment

To Connect With the World Around Us

As a Quest for Adventure

Introduction

There is nothing that stimulates and enlivens me more than travel. I get a real thrill out of being somewhere different, a new place with endless possibilities to explore. It's intoxicating, like falling in love. I travel whenever I can and feel antsy if I have no set travel plans or at least something in the works. It seems my wanderlust can never be sated. I don't know where my nomadic spirit came from, but what I do know is that traveling makes me happy, it makes me happy to the point of always wanting more.

I know that I am not alone in this. Travel is a basic human desire; we are in essence a migratory species. Although not everyone experiences an unrelenting urge to travel, many of us do have an assiduous yearning to explore the beautiful world we live in.

So what is it that creates this urge to put some distance between ourselves and everything we know? What motivates us to spend the year skimping and saving for and fantasizing about our next trip? Why do we travel? Through beautiful photography from around the world and insightful and inspiring quotes, this book attempts to answer the question of why we travel. This book features quotes and sayings from some of history's most notable writers, thinkers and passionate travelers alike.

Perhaps We Travel...

To escape the familiarities of home. Perhaps we travel because it offers us new textures, fresh smells, a sense of wonder. Perhaps we travel...

For Travel's Sake

We travel to escape, to lose ourselves in a new city, a new world. We travel for the journey itself. Perhaps we travel for travel's sake.

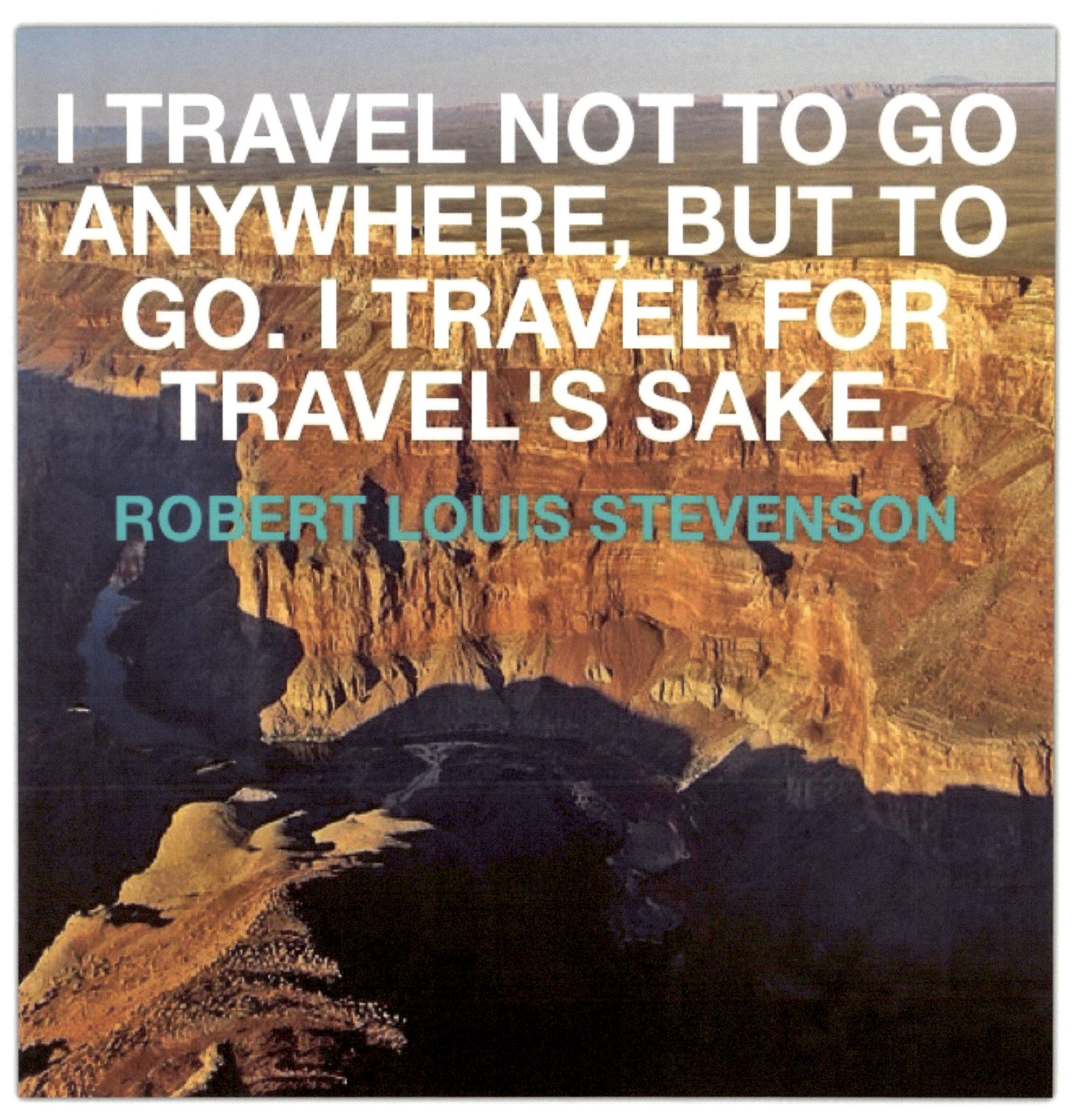

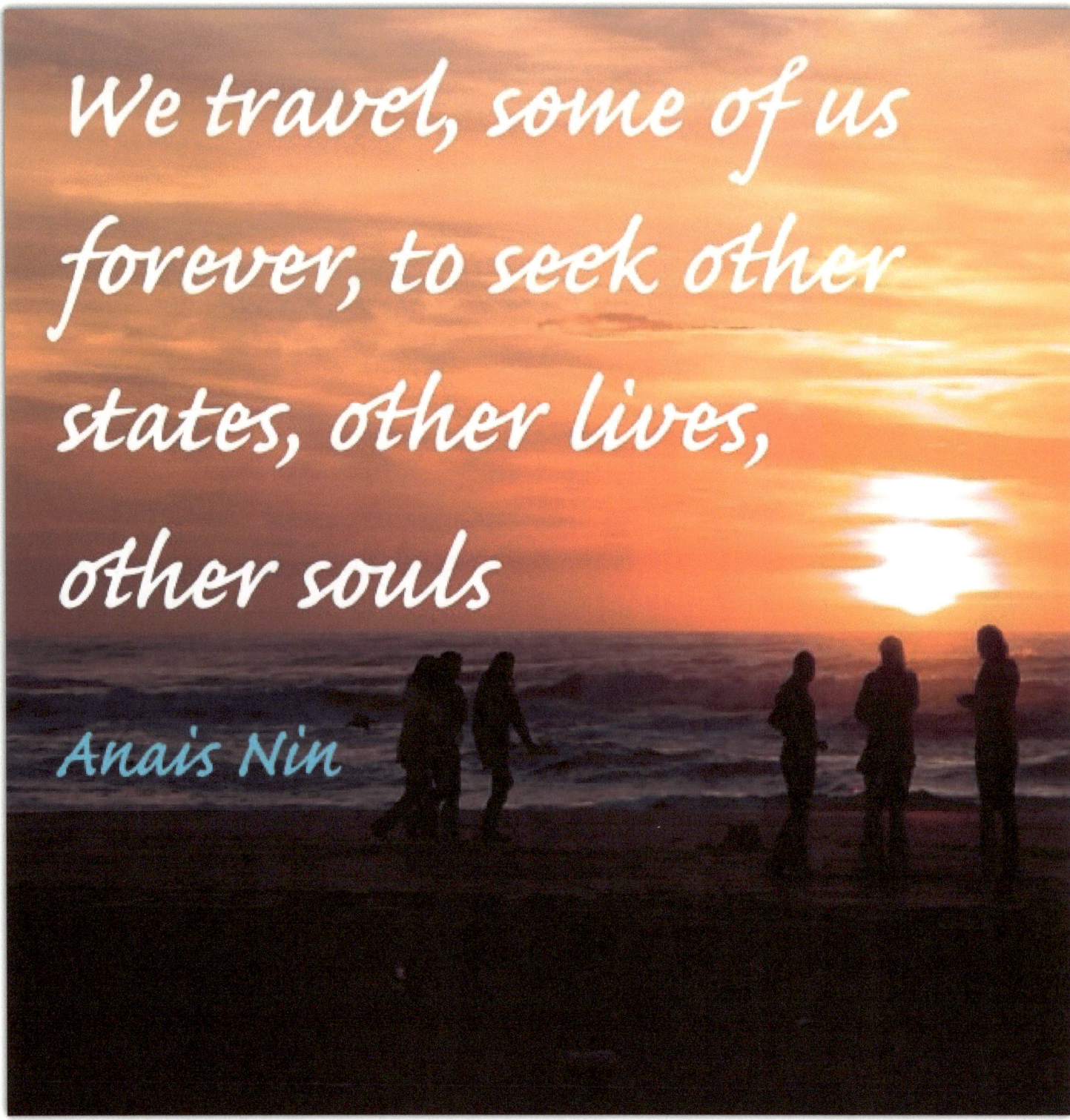

It is better to travel well than to arrive

Buddha

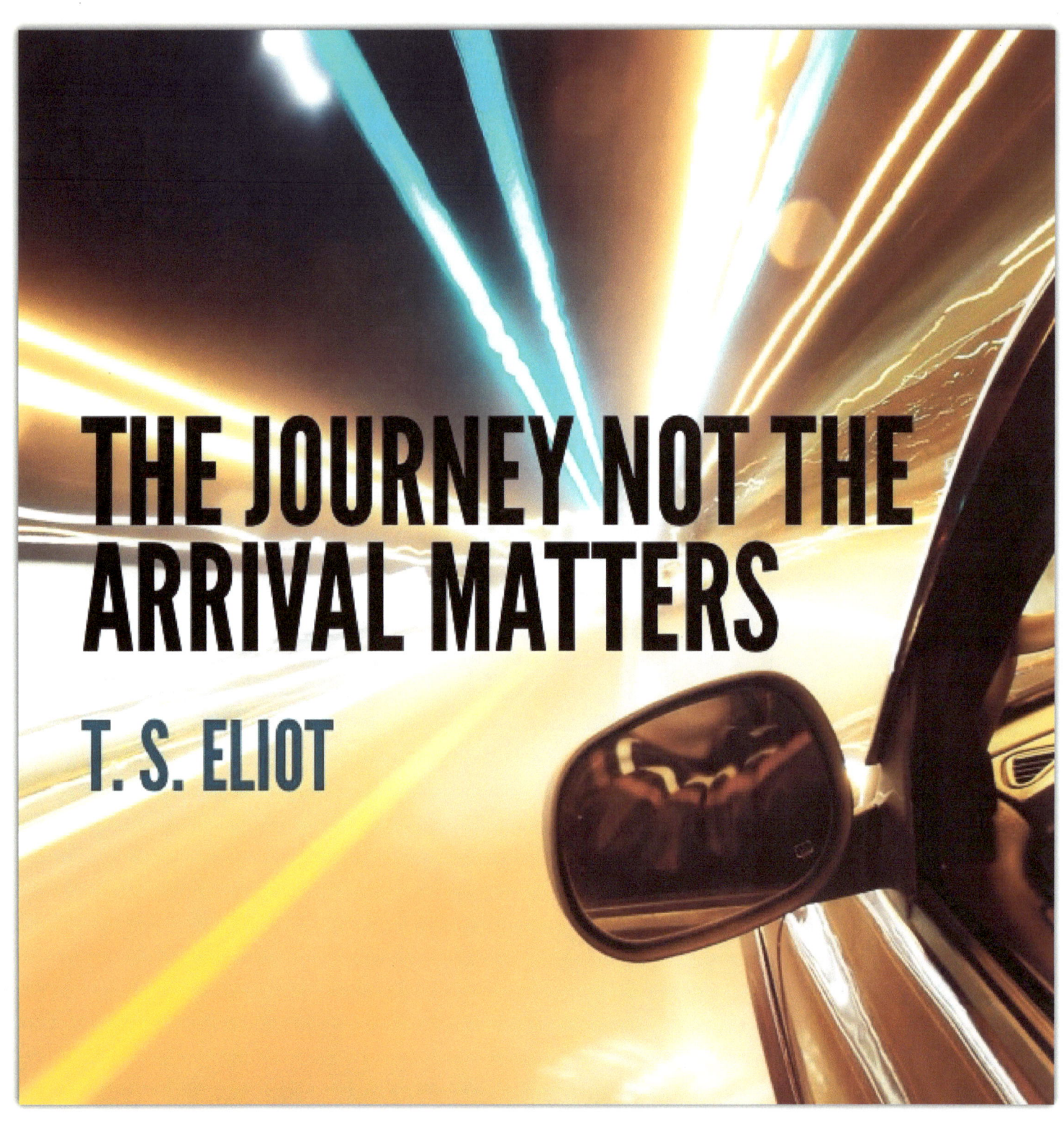

A journey is like marriage. The certain way to be wrong is to think you control it

John Steinbeck

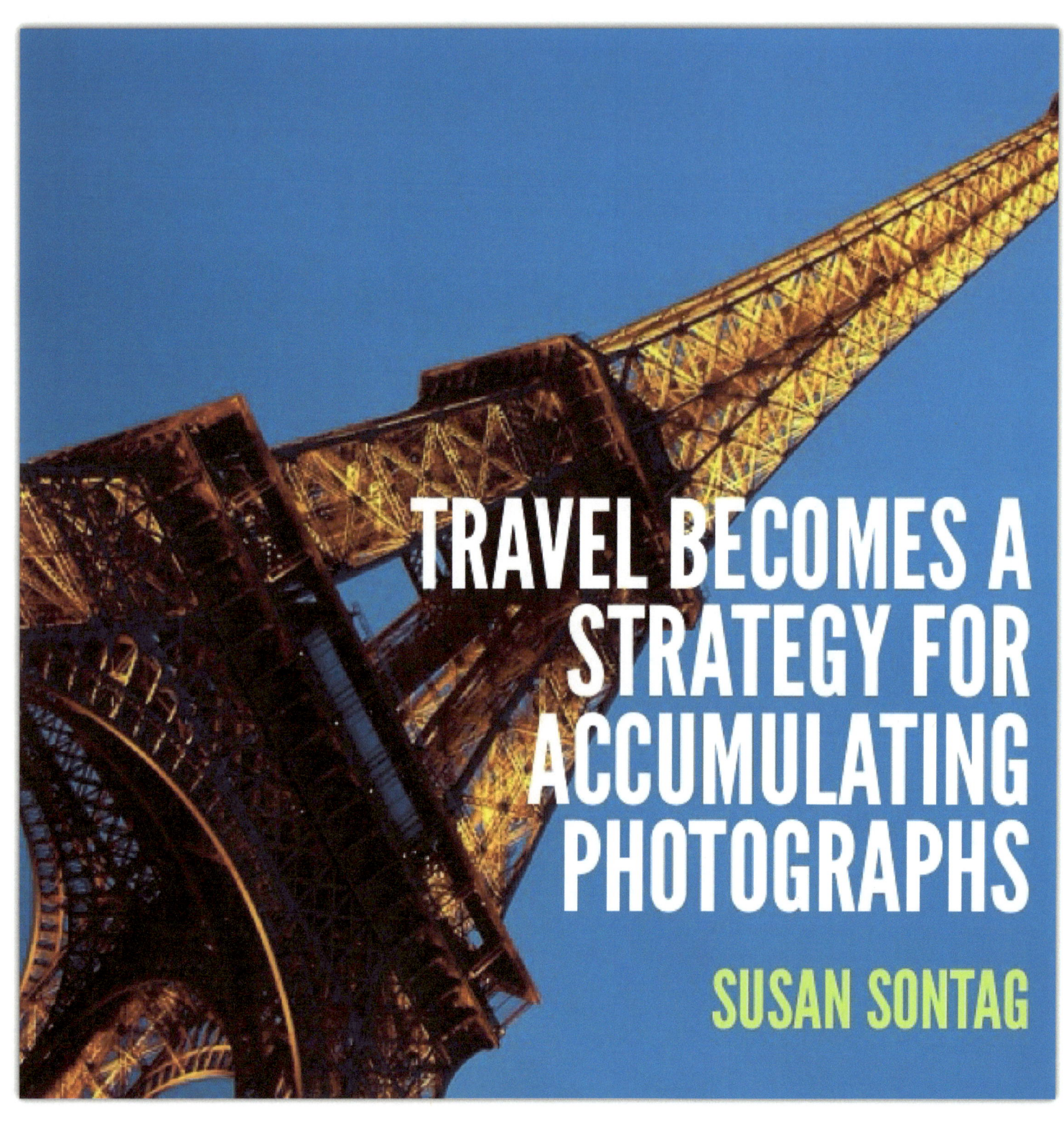

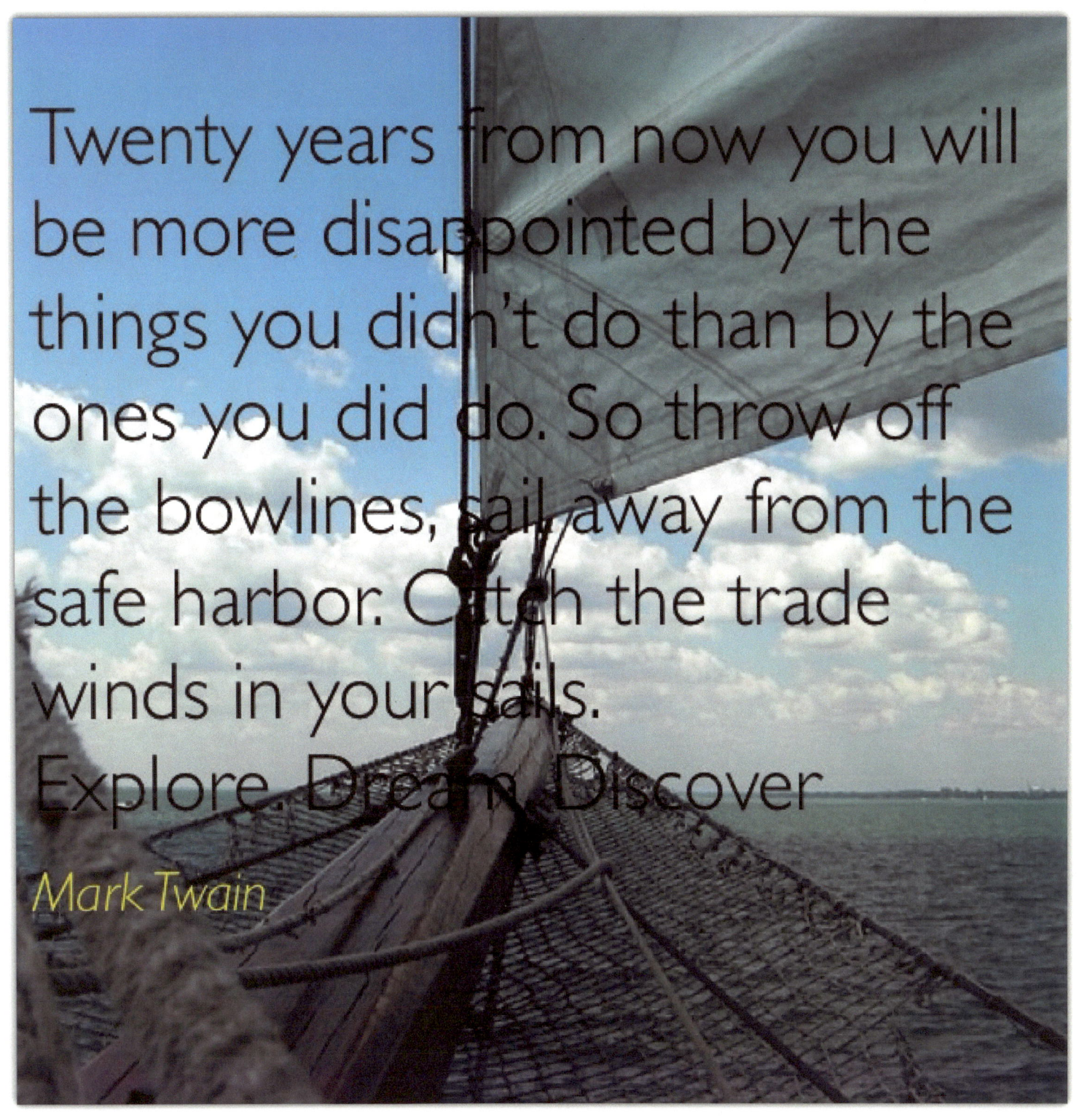

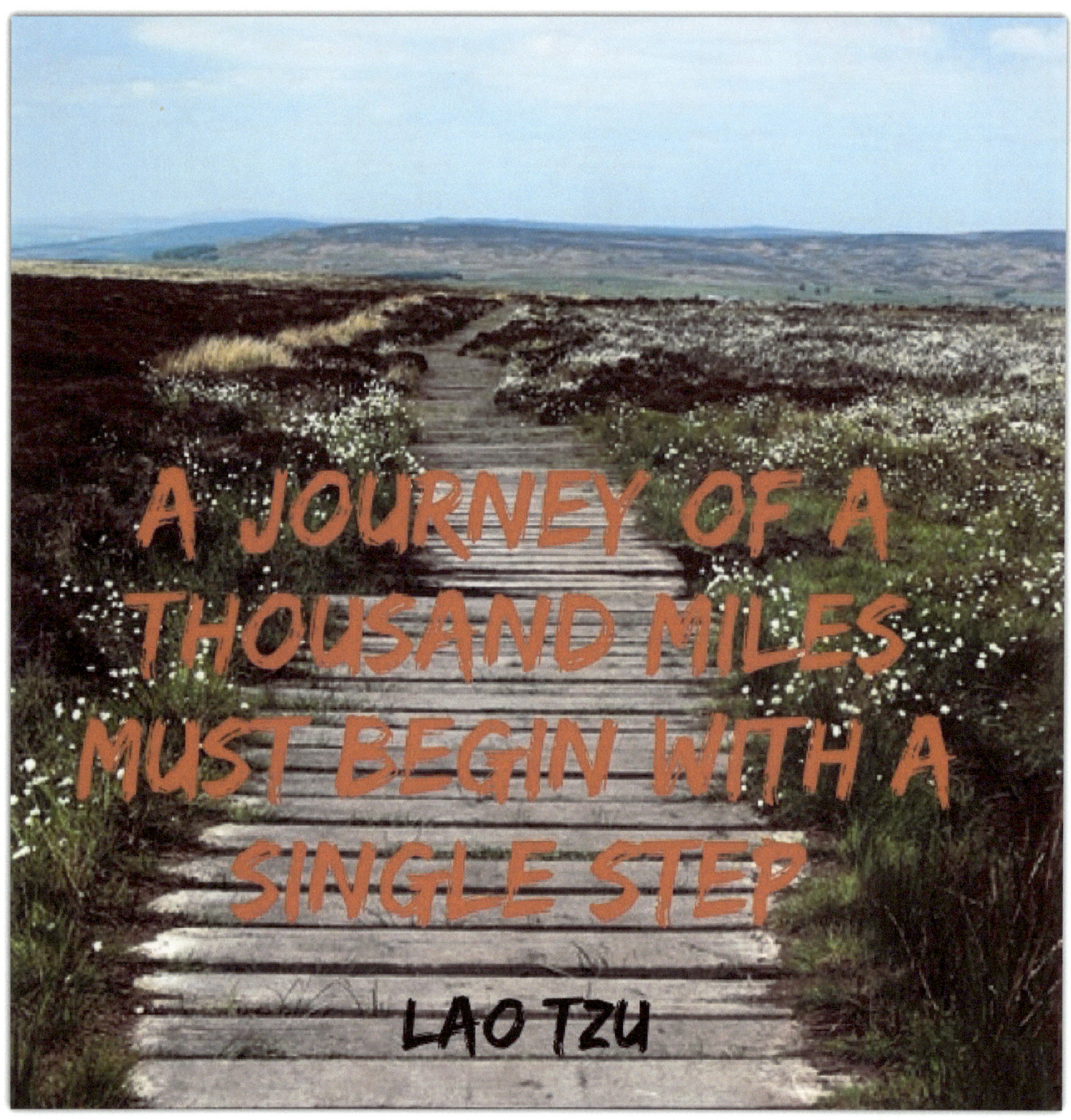

HE TRAVELS THE FASTEST WHO TRAVELS ALONE

RUDYARD KIPLING

All the pathos and irony of leaving one's youth behind is thus implicit in every joyous moment of travel: one knows that the first joy can never be recovered, and the wise traveler learns not to repeat successes but tries new places all the time

Paul Fussell

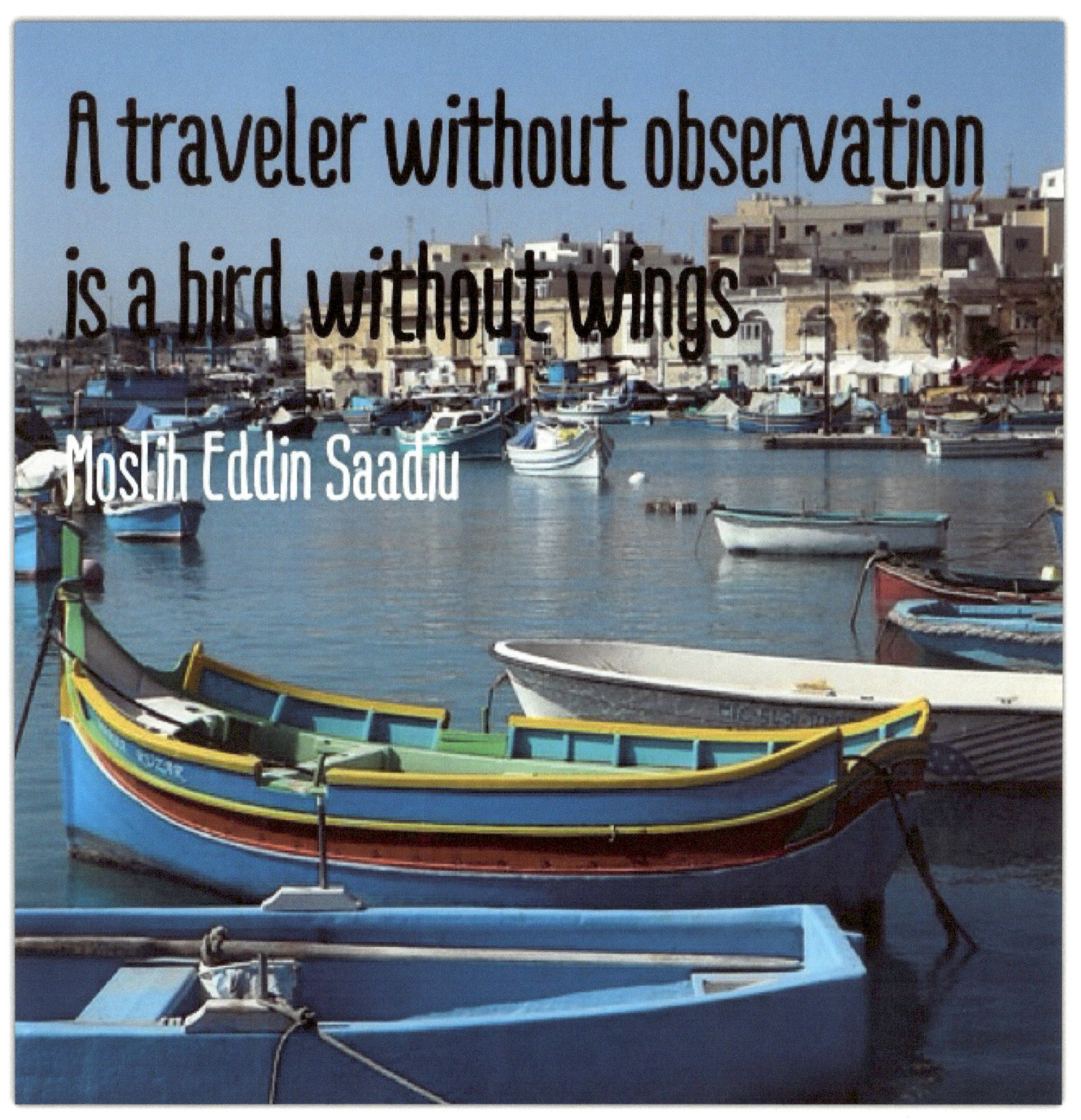

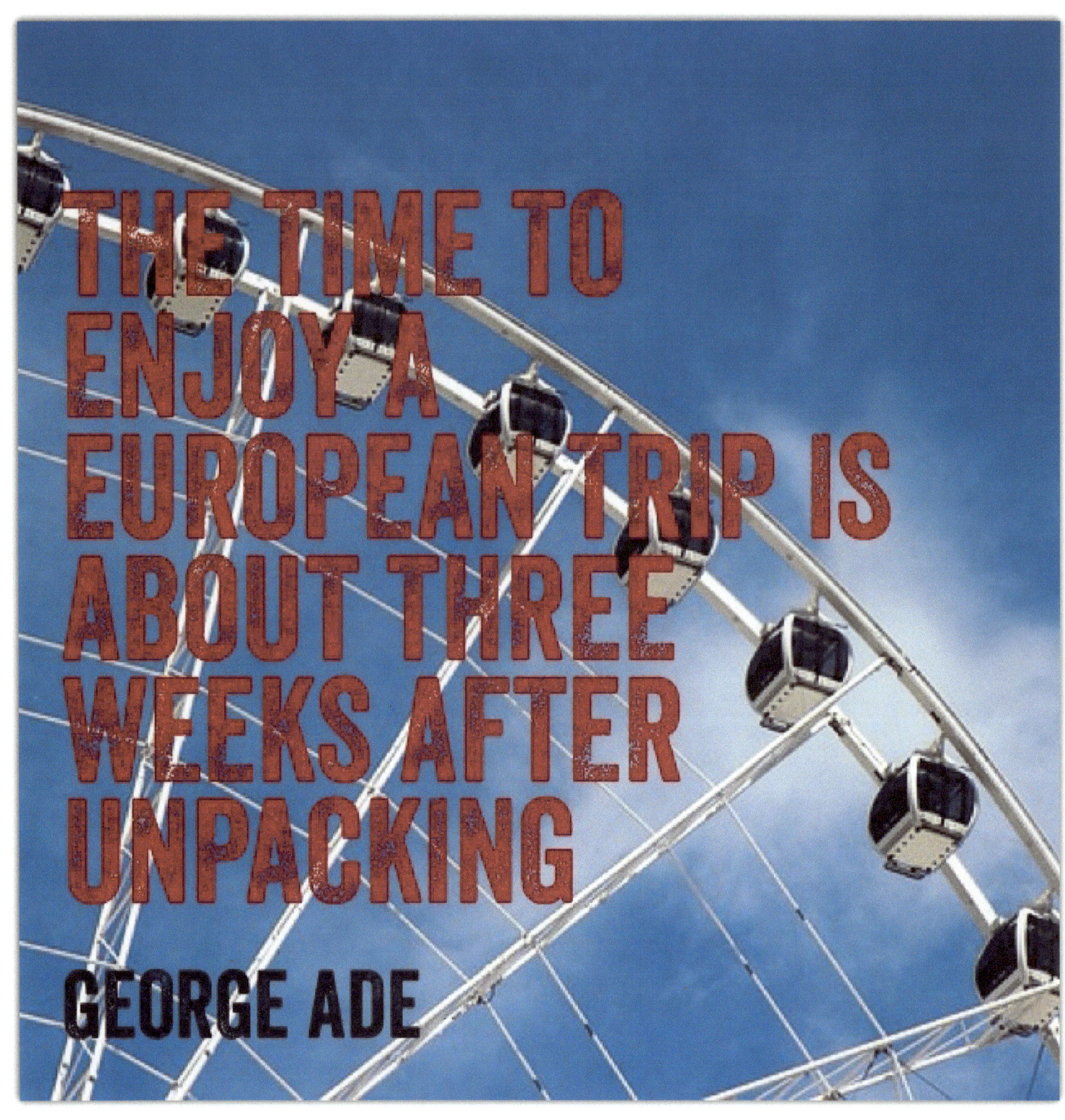

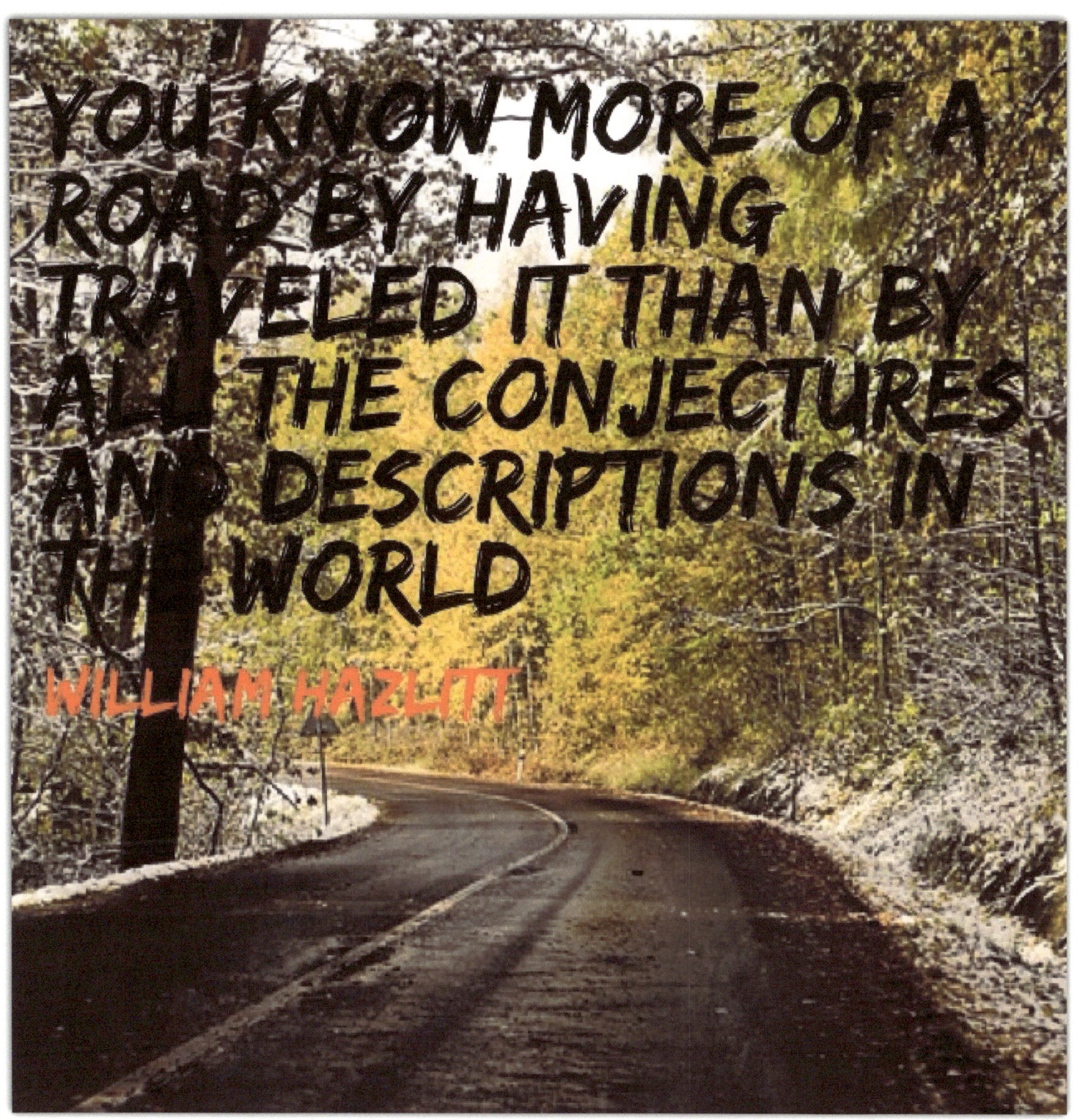

No one realizes how beautiful it is to travel until he comes home and rests his head on his old, familiar pillow

Lin Yutang

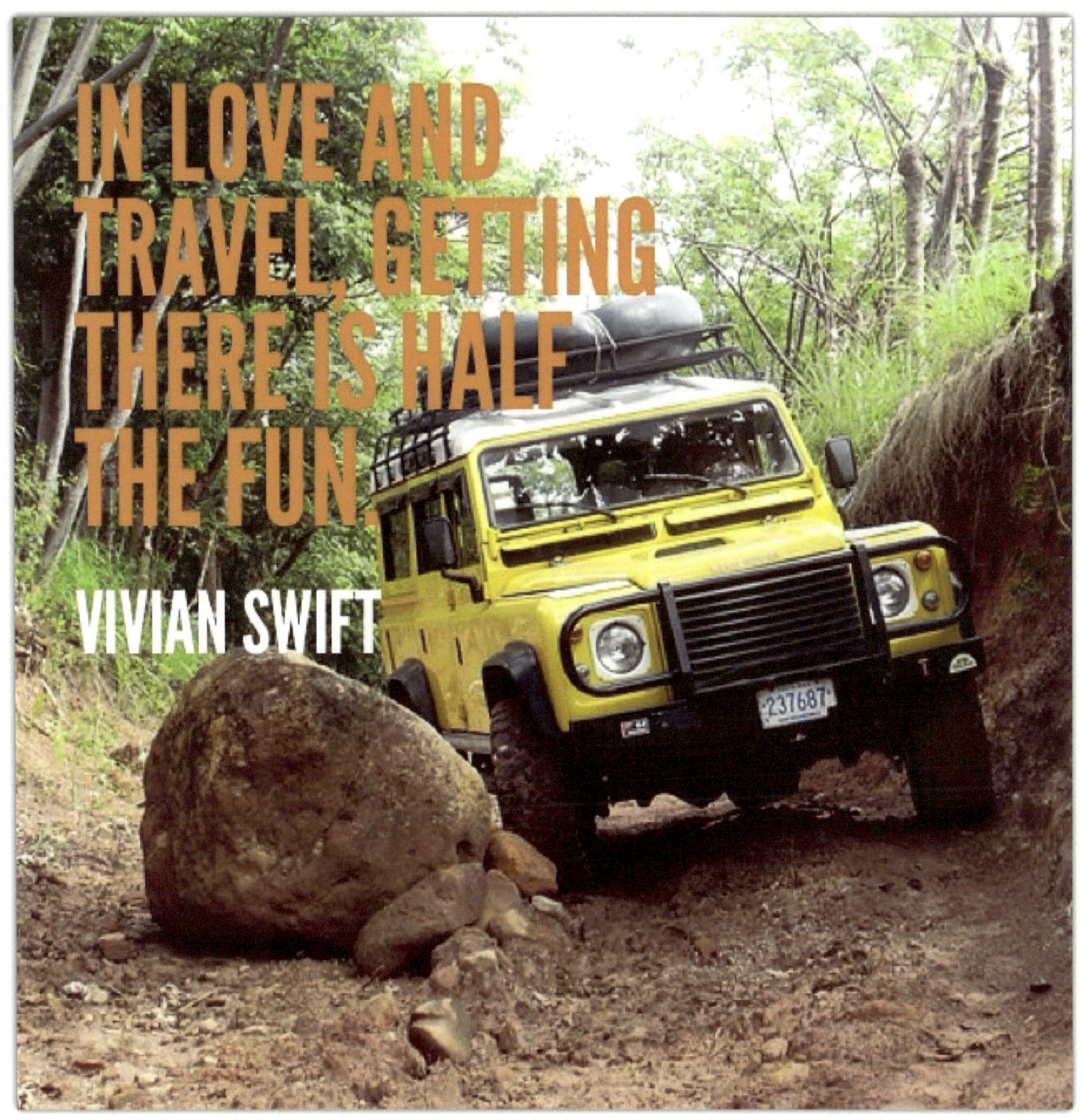

Like all great travellers, I have seen more than I remember, and remember more than I have seen

Benjamin Disraeli

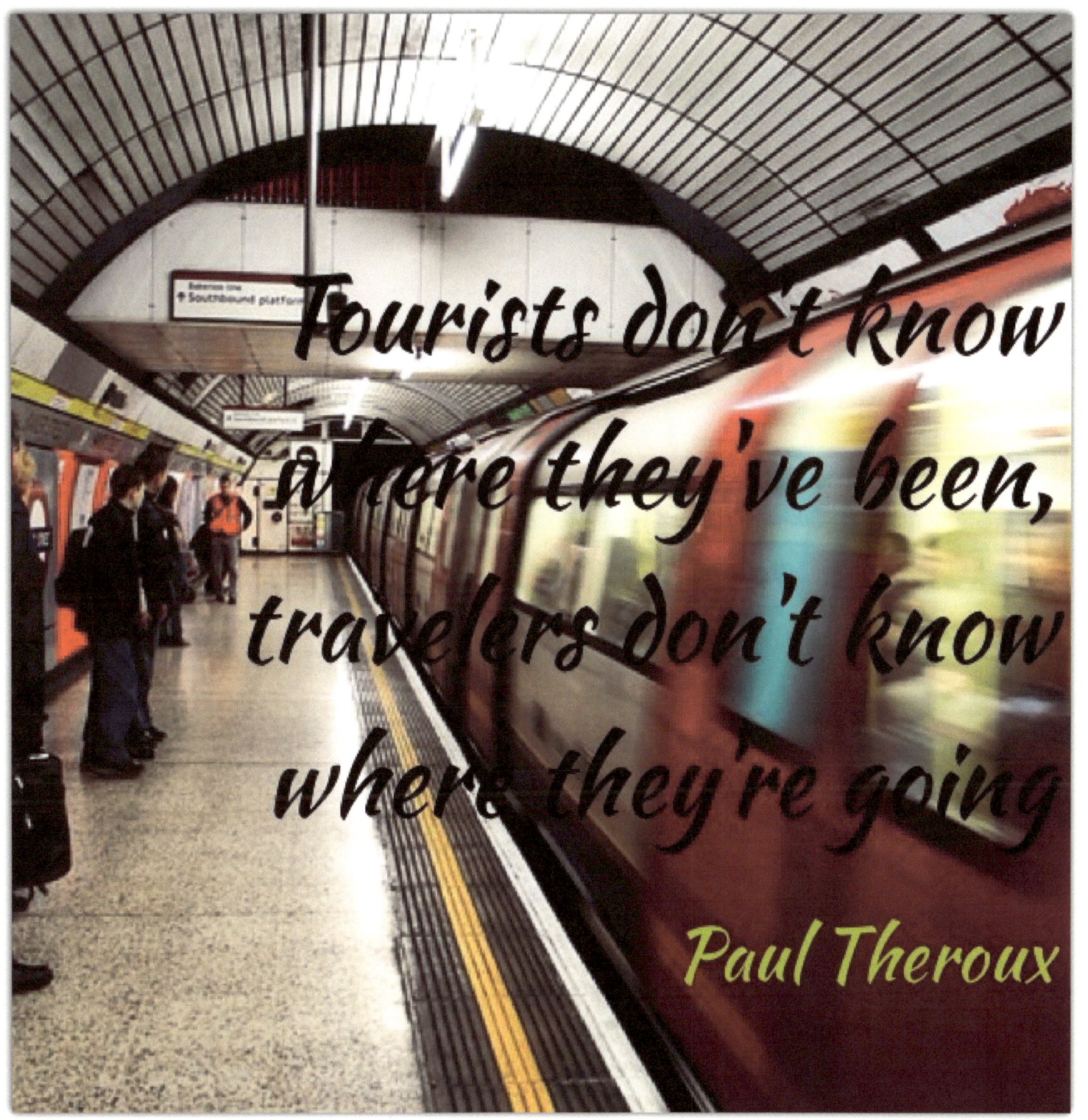

THE WHOLE OBJECT OF TRAVEL IS NOT TO SET FOOT ON FOREIGN LAND; IT IS AT LAST TO SET FOOT ON ONE'S OWN COUNTRY AS A FOREIGN LAND

GILBERT K. CHESTERTON

To Find Ourselves

Travel allows us to access hidden parts of ourselves that we would otherwise not have reason to explore. When we travel, we live without past or future; we are wonderfully free to be ourselves. When we travel, we have the opportunity to come into contact with more essential parts of ourselves. Perhaps we travel to escape, but in the end, in travel we are finally able to find ourselves.

> Not until we are lost do we begin to understand ourselves
>
> Henry David Thoreau

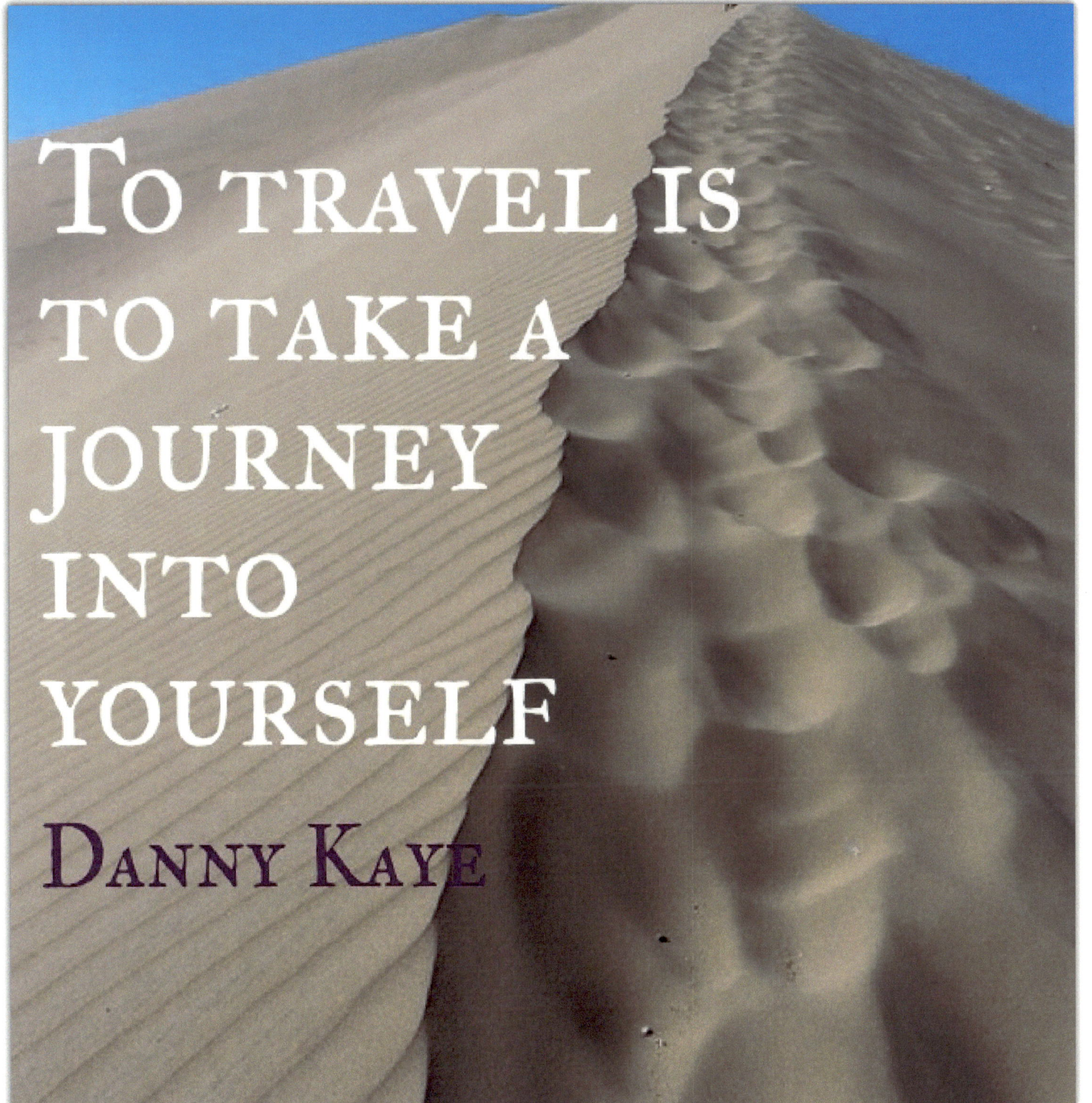

When the traveler goes alone he gets acquainted with himself

Liberty Hyde Bailey

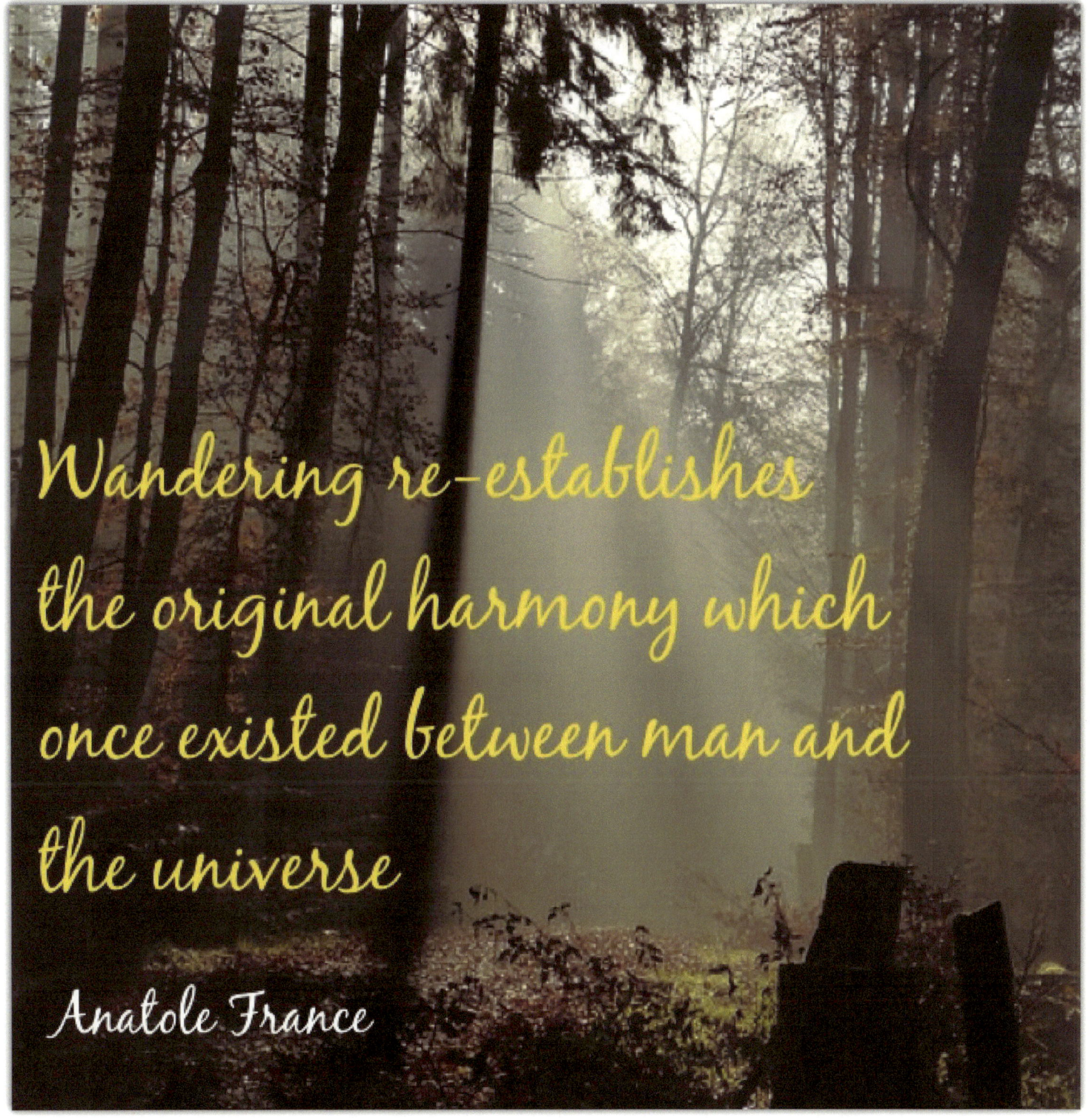

If you wish to travel far and fast, travel light. Take off all your envies, jealousies, unforgiveness, selfishness and fears

Cesare Pavese

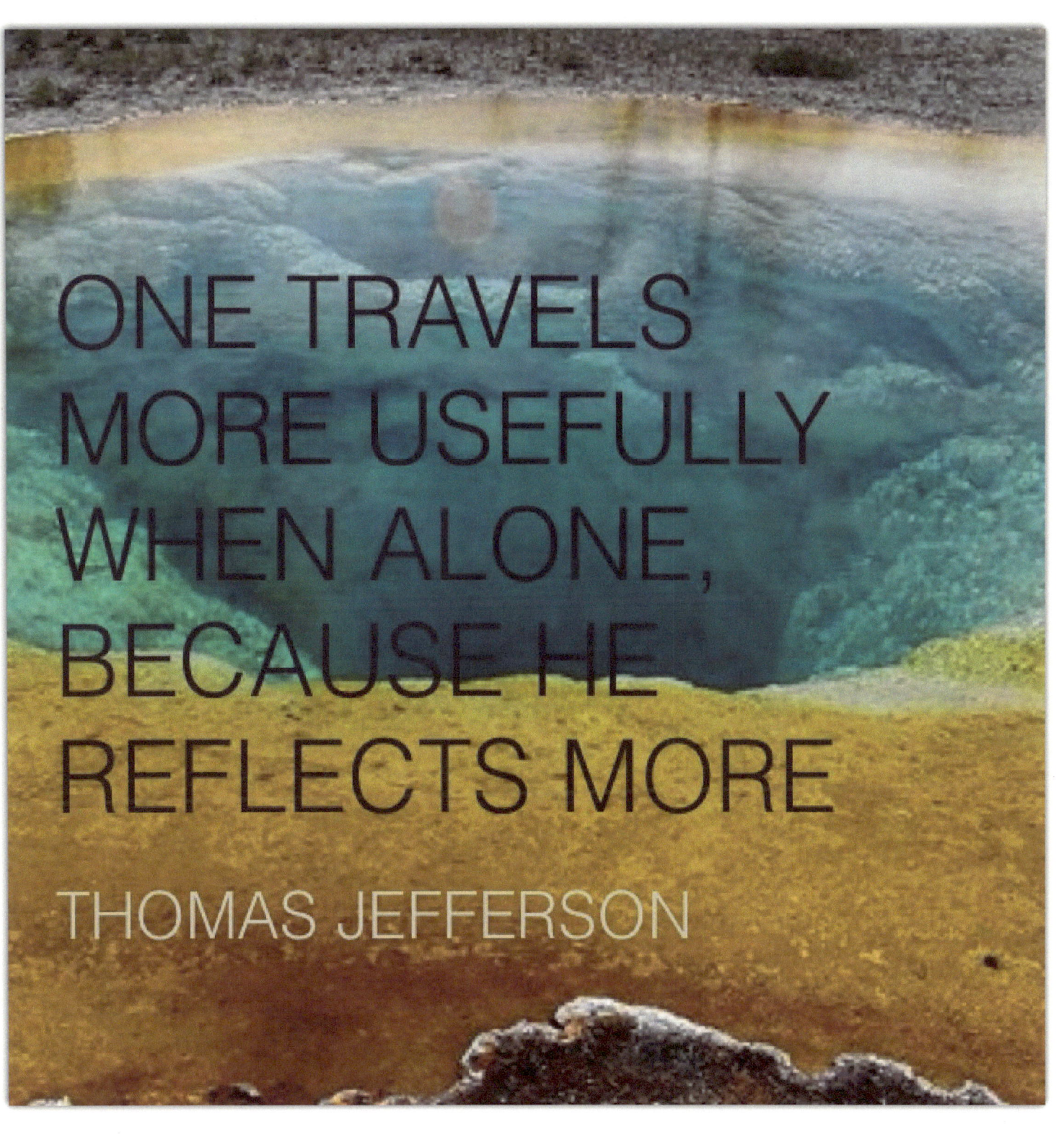

> TRAVEL CAN BE ONE OF THE MOST REWARDING FORMS OF INTROSPECTION
>
> — LAWRENCE DURRELL

I soon realized that no journey carries one far unless, as it extends into the world around us, it goes an equal distance into the world within

Lillian Smith

I soon realized that no journey carries one far unless, as it extends into the world around us, it goes an equal distance into the world within

Lillian Smith

> THE TRAVELER SEES WHAT HE SEES, THE TOURIST SEES WHAT HE HAS COME TO SEE
>
> — GILBERT K. CHESTERTON

> The land created me. I'm wild and lonesome. Even as I travel the cities, I'm more at home in the vacant lots
>
> — BOB DYLAN

Because it Opens our Hearts and Minds

Travel gives you new perspective; it allows you to see the world through someone else's eyes. When you understand how little someone else has, it makes you more grateful for the things you have. Travel can deconstruct long held beliefs and stereotypes. Traveling is an opportunity to broaden our mental horizons. Travel opens our hearts and minds.

"The world is a book and those who do not travel read only one page"

— St. Augustine

One's destination is never a place, but a new way of seeing things

Henry Miller

> Travel is fatal to prejudice, bigotry, and narrow-mindedness
>
> Mark Twain

You get educated by traveling

Solange Knowles

Travel, in the younger sort, is a part of education; in the older, a part of experience.

— Francis Bacon

> Travel makes a wise man better, and a fool worse
>
> — Thomas Fuller

The use of traveling is to regulate imagination by reality, and instead of thinking how things may be, to see them as they are

Samuel Johnson

Travel and change of place impart new vigor to the mind

Seneca

Certainly, travel is more than the seeing of sights; it is a change that goes on, deep and permanent, in the ideas of living

Miriam Beard

TRAVEL TEACHES TOLERATION

BENJAMIN DISRAELI

The world is a country which nobody ever yet knew by description; one must travel through it one's self to be acquainted with it

Lord Chesterfield

For The Sense of Wonder

Travel awakens a sense of wonder in us; we are amazed by enlivening chaos we find ourselves in, we delight in pleasant new sensations; we marble at the remarkable beauty in front us. Travel expands our awareness of all that is possible.

THERE IS NO MOMENT OF DELIGHT IN ANY PILGRIMAGE LIKE THE BEGINNING OF IT

CHARLES D WARNER

THOUGH WE TRAVEL THE WORLD OVER TO FIND THE BEAUTIFUL, WE MUST CARRY IT WITH US OR WE FIND IT NOT

RALPH WALDO EMERSON

> To the lover of wilderness, Alaska is one of the most wonderful countries in the world
>
> John Muir

Venice is like eating an entire box of chocolate liqueurs in one go

Truman Capote

> Traveling is the ruin of all happiness! There's no looking at a building after seeing Italy
>
> Fanny Burney

IF ONE HAD BUT A SINGLE GLANCE TO GIVE THE WORLD, ONE SHOULD GAZE ON ISTANBUL

ALPHONSE DE LAMARTINE

"I LOVE SHORT TRIPS TO NEW YORK; TO ME IT IS THE FINEST THREE-DAY TOWN ON EARTH"

— JAMES CAMERON

> TO AWAKEN QUITE ALONE IN A STRANGE TOWN IS ONE OF THE PLEASANTEST SENSATIONS IN THE WORLD

— FREYA STARK

To my mind, the greatest reward and luxury of travel is to be able to experience everyday things as if for the first time, to be in a position in which almost nothing is so familiar it is taken for granted

BILL BRYSON

> Nothing gives me as much pleasure as travelling. I love getting on trains and boats and planes
>
> Alan Rickmany

> To travel hopefully is a better thing than to arrive
>
> — Robert Louis Stevenson

TRAVEL IS NINETY PERCENT ANTICIPATION AND TEN PERCENT RECOLLECTION

EDWARD STREETER

Travel does what good novelists also do to the life of everyday, placing it like a picture in a frame or a gem in its setting, so that the intrinsic qualities are made more clear. Travel does this with the very stuff that everyday life is made of, giving to it the sharp contour and meaning of art

Freya Stark

OUR BATTERED SUITCASES WERE PILED ON THE SIDEWALK AGAIN; WE HAD LONGER WAYS TO GO. BUT NO MATTER, THE ROAD IS LIFE

JACK KEROUAC

For Fulfillment

Travel helps us lead more fulfilling and enriching lives. It fills you up with new knowledge and experiences that may completely shift our perceptions about the world and outlook on life.

> We wander for distraction, but we travel for fulfillment
>
> — Hilaire Belloc

> Once you have traveled, the voyage never ends, but is played out over and over again in the quiestest chambers. The mind can never break off from the journey
>
> Pat Conroy

Travel is more than the seeing of sights; it is a change that goes on, deep and permanent, in the ideas of living

Miriam Beard

A man travels the world in search of what he needs and returns home to find it

George Edward Moore

To Connect With the World Around Us

Traveling can have such a profound impact in our lives that we become better people for it. Travel helps us realize that our connections to others are indeed much stronger that we'd ever thought, even if they are on the other side of the planet.

THERE ARE NO FOREIGN LANDS. IT IS THE TRAVELER ONLY WHO IS FOREIGN

ROBERT LOUIS STEVENSON

Perhaps travel cannot prevent bigotry, but by demonstrating that all peoples cry, laugh, eat, worry, and die, it can introduce the idea that if we try and understand each other, we may even become friends

Maya Angelou

"When you travel, remember that a foreign country is not designed to make you comfortable. It is designed to make its own people comfortable."

— Clifton Fadiman

EVERY
PERFECT
TRAVELER
ALWAYS
CREATES THE
COUNTRY
WHERE HE
TRAVELS

NIKOS KAZANTZAKIS

The first condition of understanding a foreign country is to smell it

Rudyard Kipling

> Traveling, you realize that differences are lost: each city takes to resembling all cities, places exchange their form, order, distances, a shapeless dust cloud invades the continents
>
> — Italo Calvino

TRAVELERS NEVER THINK THAT THEY ARE THE FOREIGNERS

MASON COOLEY

People travel to faraway places to watch, in fascination, the kind of people they ignore at home

Dagobert D. Runes

> To travel is to discover that everyone is wrong about other countries
>
> Aldous Huxley

ALL TRAVEL HAS ITS ADVANTAGES. IF THE PASSENGER VISITS BETTER COUNTRIES, HE MAY LEARN TO IMPROVE HIS OWN. AND IF FORTUNE CARRIES HIM TO WORSE, HE MAY LEARN TO ENJOY IT

SAMUEL JOHNSON

HE WHO DOES NOT TRAVEL DOES NOT KNOW THE VALUE OF MEN

MOORISH PROVERB

Never go on trips with anyone you do not love

Ernest Hemingway

I have found out that there ain't no surer way to find out whether you like people or hate them than to travel with them

Mark Twain

"WHEN TRAVELING WITH SOMEONE, TAKE LARGE DOES OF PATIENCE AND TOLERANCE WITH YOUR MORNING COFFEE"

— HELEN HAYES

As a Quest for Adventure

An adventure is defined as an exciting or unusual experience. Travel provides ample opportunities to experience the unusual, exciting, exotic, bold, uncertain and even risky. Within all of us lies that craving, be it at varying degrees, to seek out a little danger, adventure, moments of clarity and fear, test our personal limits, and for that magical exhilaration that only comes from being far, far away from anything comfortable or familiar.

WE LIVE IN A WONDERFUL WORLD THAT IS FULL OF BEAUTY, CHARM AND ADVENTURE. THERE IS NO END TO THE ADVENTURES WE CAN HAVE IF ONLY WE SEEK THEM WITH OUR EYES OPEN.

JAWAHARIAL NEHRU

"WHY, I'D LIKE NOTHING BETTER THAN TO ACHIEVE SOME BOLD ADVENTURE, WORTHY OF OUR TRIP"

ARISTOPHANES

adventure is a path.
real adventure ~self-determined, self-motivated, often risky~ forces you to have firsthand encounters with the world. the world the way it is, not the way you imagine it.

Mark Jenkins

YOU DEFINE A GOOD FLIGHT BY NEGATIVES: YOU DIDN'T GET HIJACKED, YOU DIDN'T CRASH, YOU DIDN'T THROW UP, YOU WEREN'T LATE, YOU WEREN'T NAUSEATED BY THE FOOD. SO YOU ARE GRATEFUL

PAUL THEROUX

It always rains on tents. Rainstorms will travel thousands of miles, against prevailing winds for the opportunity to rain on a tent
Dave Barry

Not all those who wander are lost

J. R. R. Tolkien

CPSIA information can be obtained
at www.ICGtesting.com
Printed in the USA
BVHW021144121219
566483BV00008B/71/P